Coloring Book: Bible Creation

A.G. Johnson

Copyright © 2020 A G Johnson

All rights reserved.

ISBN: 9781542469920

INTRODUCTION

I created this collection of my hand drawn images because I love the Biblical depiction of the Creation of the Earth. I have always been an unashamed faithful follower of Jesus Christ and I dearly love to share the message He gave the world with others.

By making this book my wish is to share not only the love I have for Him and His gospel, but also the love I have for learning and science. There are many who believe that science and religion do not mix and some who insist that science "proves" the scriptures to be false or misleading. I disagree and enjoy seeing the correlation between science and religion. I believe those who have truly dedicated themselves to the study of the word of God and understand the way the Bible and other scriptures are written will be able to open their minds and hearts to the possibilities of how God works.

I believe in God and believe that the power he possesses and uses to create the universe and to bless His children here on the Earth can be explained with science. There are some who get stuck on the "timeline" of the creation story as it is written in the book of Genesis in the Bible ; that the world was created in 6 days and that the later analogy of a day to God being equal to 1,000 years on earth means that the world was created in 6,000 years. I have spent years studying the words of God, the stories and analogies in the scriptures and as a result I truly believe that the comparison of days on earth to days in Heaven is simply and example. God has no beginning and no end. Time for God is irrelevant, and the numbers given in the Bible were simple an example of that. It is my belief that the creation of the world did in fact take millions of years and the "6 days" as they are referred to in the Bible are 6 phases or time periods that happened during the creation.

Day 1

Day 2

Day 3

Day 4

Day 5

Day 6

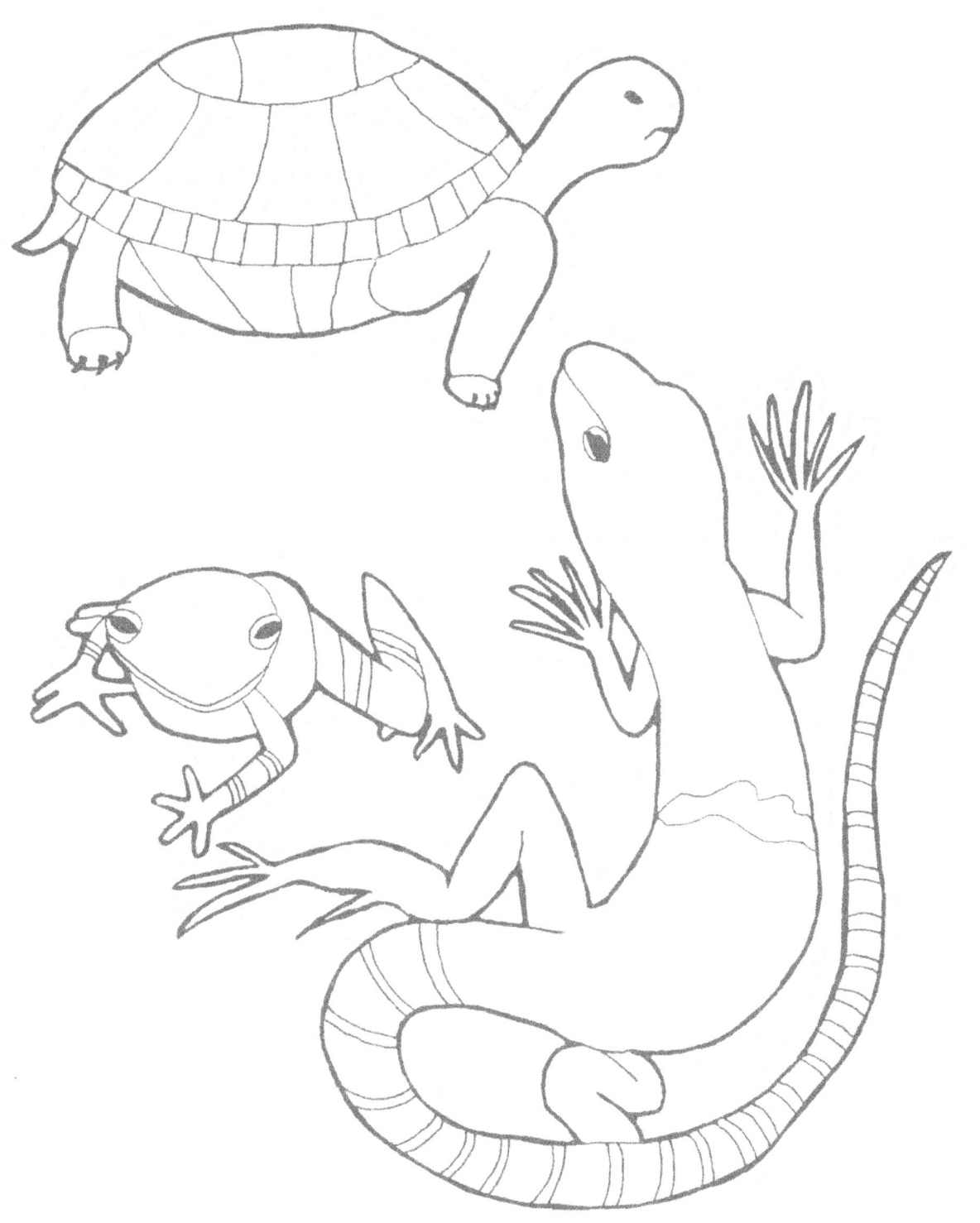

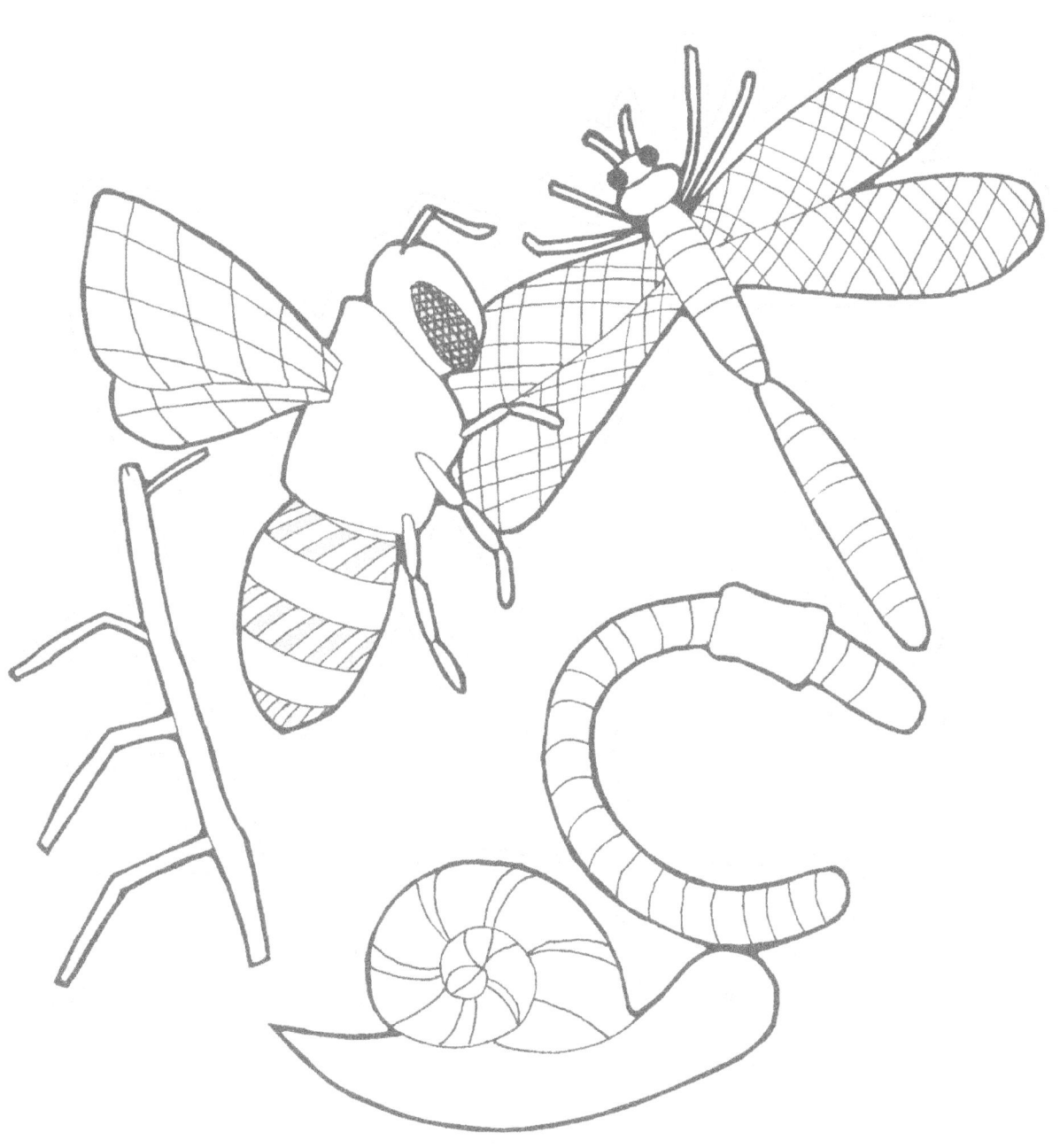

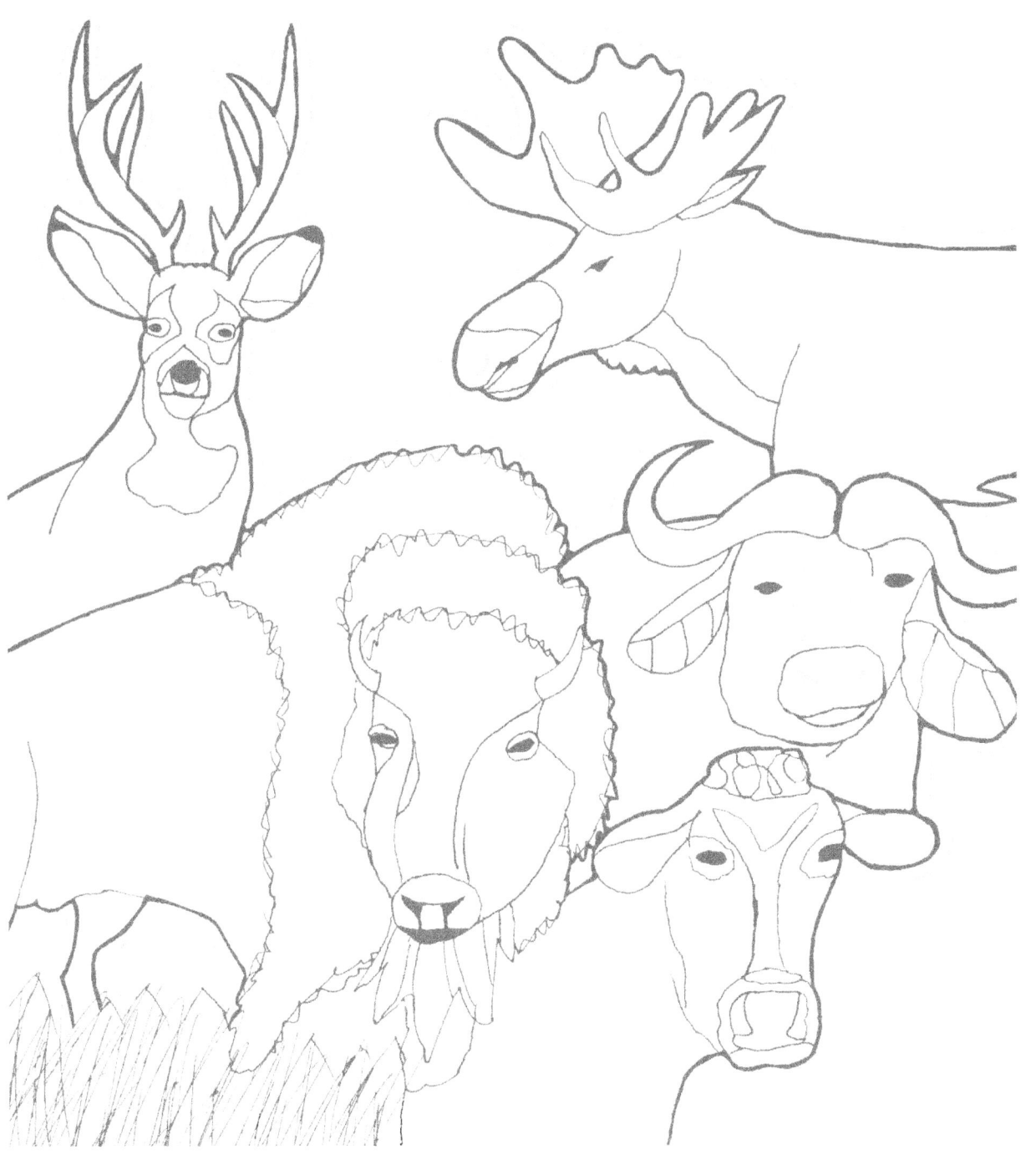

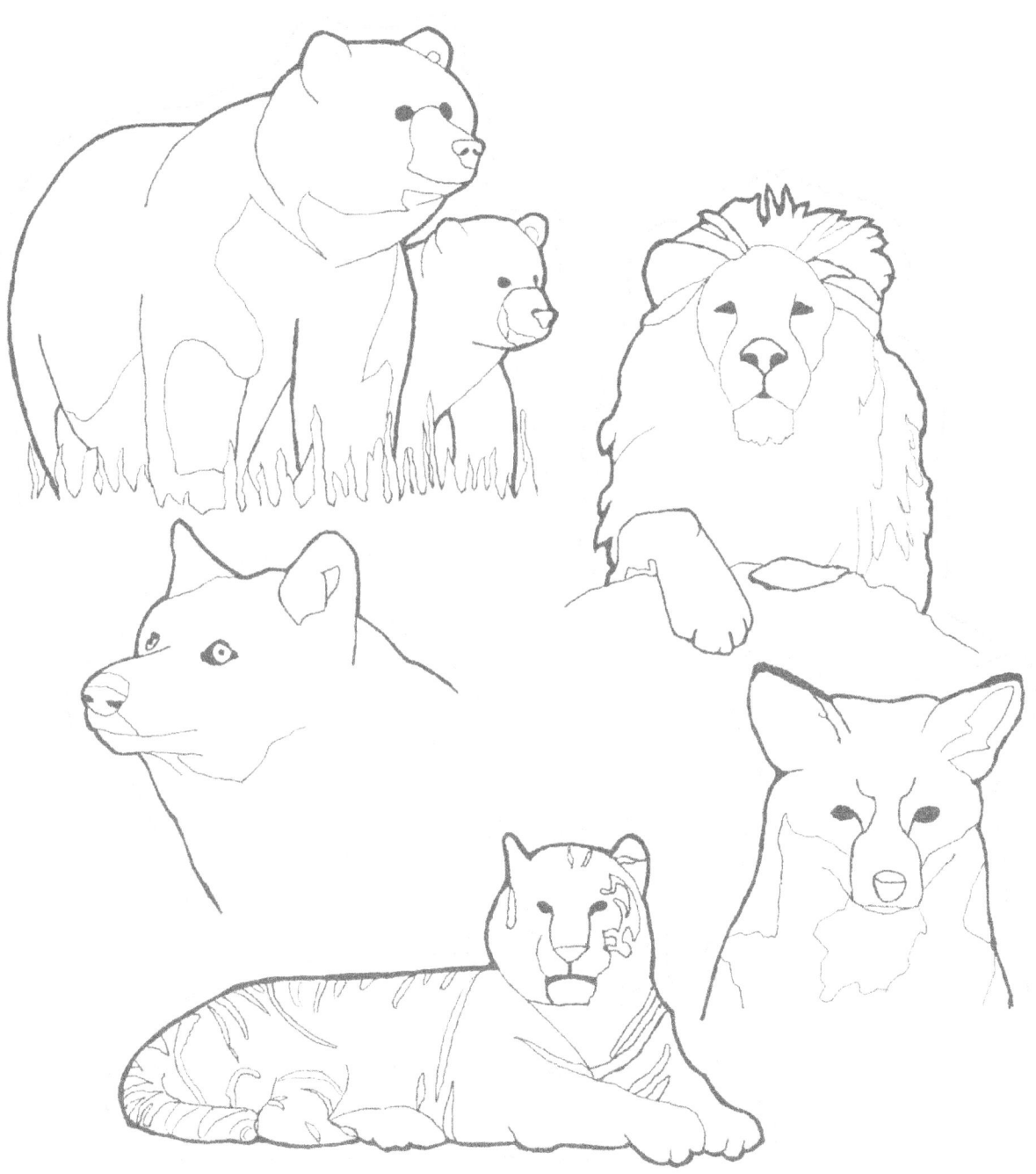

www.ingramcontent.com/pod-product-compliance
Lightning Source LLC
Chambersburg PA
CBHW081122180526
45170CB00008B/2962